NEAR, AT

FUTUREPOEM BOOKS
NEW YORK CITY
2019

NEAR, AT

JENNIFER SOONG

first edition | first printing

This edition first published in paperback by Futurepoem books
P.O. Box 7687 JAF Station, NY, NY 10116
www.futurepoem.com

Executive Editor: Dan Machlin
Managing Editor: Carly Dashiell
Associate Editor and Copyeditor: Ariel Yelen
Editorial Assistant: Aiden Garabed Farrell
Guest Editors: Monica McClure, Pierre Joris, and Claudia La Rocco

Cover design: Everything Studio (www.everythingstudio.com)
Interior design: HR Hegnauer (www.hrhegnauer.com)
Typefaces: Palatino, Letter Gothic Standard
Printed in the United States of America on acid-free paper

This project is supported in part by the New York State Council on the Arts with the
support of Governor Andrew Cuomo and the New York State Legislature. It is also
supported in part by public funds from the New York City Department of Cultural
Affairs in partnership with the City Council, as well as by The New York Community
Trust Harris Shapiro Fund, The Leaves of Grass Fund, and Futurepoem's Individual
Donors, Subscribers, and Readers. Futurepoem books is the publishing program of
Futurepoem, Inc., a New York state-based 501(c)3 non-profit organization dedicated to
creating a greater public awareness and appreciation of innovative literature.

Distributed to the trade by Small Press Distribution, Berkeley, California
Toll-free number (U.S. only): 800.869.7553
Bay Area/International: 510.524.1668
orders@spdbooks.org
www.spdbooks.org

NEAR, AT

NEAR, AT

THE AUGURS

Come July, the yolk of a year
is dragged to lie on lawns of velvet sheen.
Dark-light blades, one-tenth-an-inch wide
over which the red sun hunches, immobilized.
With what do we lie, waiting the night
and the hot black earth to erupt from us
a muddled report? How little we do.
How little we rest. How much we demand
from the daily murders passing
Vulture-like, like stars.

I.

MICROCOSMOS

The sea distributes clouds left to right hot clouds clunk sky into
buttocks thighs stripes the color of shadow on sand beneath
staggered rows of comfort-face-down loungers: a Minute Maid,
squashed

 like a left big toe pointing into the sun a woman

 dreams the gender of "soo hilarious"

 as it scratches the arch of the other foot

 A crave for new mathematics (is some itch-like sensation

•

Running through air the green-coral paisley of their shirts
 identical boys run in the
complementary brown
 of the streaked-river-bark-swirl
 a summertime cloth

The side of one's face as it chases) caught then completed by

 the side of the other's

•

Up into along and through the boardwalk the woman says
"the houses go 'gray white beige beige blue'" Meanwhile
the houses say "she goes

 'gray white beige beige blue'"

•

The sea distributes inland towards the boardwalk

When a face is being tossed
 as it may or may not like what it sees
the sea distributes
 "You're it"
in the room later
 the man says to her
"how dashing"
 the sand cools, the wind wanders
along which side
 she usually sleeps

•

Into the hotel carpet bodies loosen from sand as towel swans watch
 through dimple Tiresian eyes.

The man and the woman feel their parts vanish in one another, after
 which she leaves to adjust the shower knob. She takes a

part the bird-wings the working women won't tuck back till tomorrow.
 She steps in

like legs, and in adjacent rooms, rows of the different same linens are
 cropped. Cropped

like one perspective intervening in another. The working women's hands
 slip into, fold her heat

in some other room she is not wanting to but actually asking them

to show her willingness she moves hot water across her chest

an upward splash while the man's voice through the obscurity of thick
 shower frost is a chamber

a chamber of voice and voice, missing nothing but the clarity of
 decipherable words unlocking What

is the case of a gendered laugh? Soon,

dimness fills the room like air in a bread loaf: a vertical light, caught,
 flexes where the rodded

 curtains don't meet

•

the ground

 In a small bit

 as in a moment of
 given sky or

 as in (she thinks)

 there floats
 a plane
 like a
 plus
 sign

·

A funny thing
is a small thing
but not
 "*soo* hilarious" as he once said
she said as in "how strange, how funny…"

There's a way in which *It* gets tossed from this to this
and that, which is she, is unseen looking

•

The expected arrival into Miami is as they say "on time." A contract between belief and assurance makes for an orderly day. But as planes fly low in these regions, she extends her arms to exceed the line, a change in relative speed between two aerial masses; turbulence, its aftermath, its angelic fart tracking the sky.

•

Like a wrinkle of gum, intentional delay

works itself out

a starved creature, like the spearmint gnawing taste

from an egg-flavored square

she bought what seems like

forever ago in this limbo waiting

the woman swallows the POP

•

The woman swallows from her ear the *POP*

 and his voice through the glass

 lapses between the distribution

 of curves sharpening a sea (these voices in their ears work to meet

 the ground

 of words in their heads) or perhaps

by way of a longer path, like parts past

 the canal linking the middle ear with
 the back of her nose, through the segment
 of the pharynx that extends from the
 skull's base down to the soft palate fleshy
 with mucous and baby-like pressure as if
 the throat were trying to tell her she must
 open silence with her mouth

•

The stuttering of stutterers is known she read

to stop when the act of singing or whispering

 undertakes. Therefore

•

Therefore there are times when tenses without reason

shift

 e.g. light running its perfect minted form like a magnet along the golden
 camelback

 e.g. meniscus, need and study

 e.g. the value of

 e.g. two fingers in peanut-butter looped in sealed oil. The value of
 something dripped freely

 with the texture of staccato or

 e.g. the sound of live humans

 again on morning FM radio

 shouting with a certain certainty

 a certain *POP*

 which shatters with a force-like-blockage the voice into discrete words

 as if the human cage could be exoskeletal, accommodating the growth

 of single-player gestures in a forest of paisley

 or from a shirt pocket the blue cloth hanging like a wing-clipped bird

 calling out the page number in a Bernadette paperback

recalling how southern palm trees in their defiant individuality

refuse to take their seats

and the marble-swirl-eye-sky, gathering around the plus sign

as if it were a new counter-centripetal force, an influence, a splash

compatible with cars passing and passing a woman again as she
passes them

never taking the anticipated exit or letting the freeway stop but

skating to-and-fro like infinite skidding

never landing the exact position of the morning body having
lifted from the

great white gray

pile of down

to swim in the sea

knock and work the heavy parts

the new sounds hard-earned

on the Klein-blue tarp.

II.

THE THINKER

Two nights in a row
I have emerged from the black greenery, myself.
There on the city's corner
a West End hydrant
pours crushed water from its belly.

Releasing, as if it were a slow fire
the water gives, admits to the age
of heroic facades slid onto ruffled awnings
to embrace anonymous pipes.

Like the second-to-last hour
the burning spring is almost over
or just begun.
The sound of power, so steady,
is almost silent. At the end of the block
one street becomes another and another.

I hear it now as one hears oneself.
For a minute, I think I know
what stays and is gone, what exists
on those rusted blades of grass,
guarding this last, ubiquitous earth.

UTTERANCES OF THE OCTOBER ASIDE

Today I feel better. Again I see the trees.
I call my mother, attend the morning lectures.
Spot the discarded pathways and
pass them by. The corpses of leaves everywhere say hello.
 Still, is anything lonelier than
a feeling? Or the clear wiring of tubular store-signs
when the people awake?
The awfulness of last weekend's brunch, poached news
for the dogs: I asked about M—What was it
she said about C? Always C, but
we're safe for now. The dead and ex-
communicated won't arrive for a while, their dirty reminder.

On drooped-stretched wires the pigeons squat
like notes on the trans-New-England stave—
Whose memos get mixed up in there?
The cardinal drafts are disinterested.
They play double-dutch, conspire with the storm.
The night never prepares me in time either. It slides under
always as I start to settle—though Yesterday Part II
is a poor sequel and I'd rather tomorrow show up
like it does: hungover.

To the store I walk coaxed with the breeze and
against it on the way back.
I'm still moving through. Nowhere in mind

but probably late. It's fall and I've
left my batteries at home, along with Page 75
of a vulnerable but sweet Frank and Jane. I hope they don't get
too blown away, lose their place next to
what blue-looped milk is left paddling in the soured bowl.
 I go by the schoolyard where all the mothers
are cuckoo. How the children still cry, weep
without having to be asked—Oh,
how many selves have they yet to get through? Or are we born
with a set number of losses, twisting off Russian dolls until we break even
our share?

There are places besides Mill Street, Massachusetts.
There are places besides here.
Dear Mother, will you pay the fare? For I've dreamt already
of the other country, the one where I am
Woman of the Pomegranate Farm, have all those
Chinese lantern fruits fall, cover me blushing.
Would I wear stained rivulets on my chapped, winter-
lips? I might be kissy-faced.
I would speak no misery.
 But here's a corner I recognize—sunlight
strikes again through my neighbor's yard. Who's to say it's trespass
when the sun's entered and left the gate open?
I behead the roses until they stink of love.
With some clothespins I hang them like bats in the closet.
They too must learn to get drunk with the ancient Styx.

ÉTUDE

Saturday rain, and the trapped vapor clings
to the roof of your coffee lid. Outside
the burning of your cigarette floats back
to smoke your face cold. It fails to transcend
the portrait of your carelessness,
your young, bookish loss. In the barred trash
an umbrella sits shot, stubbed like a first-world dracaena.
Your Newport specter dances in his underwear, rummages through
your Barbour coat. Water slips
from the lonely wax, the exterior claiming futility
as nonchalance. The thoughts, your triumphs
merely hover, tortoise-shelled—and how you've failed again
to shed your need for love. Robbed by and from oneself,
the faculties are as embedded forgetfulness were,
a shadow you see but cannot lift to confirm.

THE VOYAGE NOWHERE

Neither the dream, recalled or escaped,
nor woman as dreamer extracted.
I think what picture's traced of me by night,
what shape-shifts on a bed, covers like ocean laid to
my queen-sized deck. I think and am
as good as guesswork. I resort, go do
as the shadows would have me do,
what they too have done to me: each night,
following as a loyal dog does up the stairs,
into a room kept every size by dark, where
climbing the walls, they grow tall like giants—
Hovered from above, what do they see, or else, what
am I but semblance, the captain's parrot, alternating
halfway across the sky between silence and mimicry.

SOME WEATHER

to J. J. Wieners

The wounds of weather recall us to them:
wet stones, wet benches, a wet wind.
The wedding and roster are the better day, though
your babes would be born as soon as now
alongside the ill and self-starved. In these wards
some know a hope which wills into existence itself.
Their season bears the semblance of leaves, as if they
with their leaves, could recall which wind
in landing, did not end. Into melodies each malady
would amend itself—the necessity of a distance
not ceasing to oppress just because man survives
or because "man has turned backwards
against man himself." The pool, empty with water,
reveals on its rim leaves clinging like children, and
having travelled so far, lightning does not midway

change its mind, though I am bound to this afternoon and
to think it could, for in falling slowly it would achieve a
certain crudeness with which man might think it touchable
and say of it I have felt through it with my hand so I am
still with hands which may appear to you as touchable.
When will that which decides us human
hold to its face the rain, its ornament?
The Little carved Vintur regards his runny nose,
thinks us neither "all too" nor "only that."

SCRAPE ME FROM YOUR MIND. AN URGE

Scrape me from your mind. An urge is the time
but crueler. Can't you hear the damage now?
The shock held down by whorls of night-thoughts intermingling.
Our lives merged without shifting lanes, the contour
outlined like a Basquiat, where skull-shards are sewn up, sun-
slabbed in a high-voltage cadmium. Don't pick at the scab. I know you
desperately want to because of that terrible chafing beneath
the cortical surface. But subterranean is where memories, these,
are most at ease.

You once asked *How far must I go
before I call this war my own?* All through the forest you searched
for the painted cherries. Buoyant bunches and the original legends.
The glittering kaleidoscope weakened the compound-mosquito eyes,
but through the trees the sun came in hexagons.
You slipped the severed cities into sleeves and slit roads, long letters
to everyone who left the deep cove of evergreens
for the great urban epiphany.

For months no one responded.
What myth is there but the one you construct. I knew style
to be a mythical creature, but still I wanted
and believed in a unified self—Didn't the poets
pass us down and pass down the seeds of sorrow too?
If words still take away so carefully the world, have them
look our way at least. Hey, are you listening

to the world happen? No one told the trees which way to grow.
They readily loved, made sweet their own time. Down
at the fruit-filled roads, where baby peaches fall to their sound, looking
as young gifts or clothed happiness do, all things are eventually taken,
all things eventually asked. But if
tomorrow the world crosses this way, starved
for extinct breeds, let them know we let down arms
for the suspension of low hollies held between.
Nothing is ever just a look. It is always an affair, and time takes us everywhere
down in its book. I scribble down another "if," one that might catch me in its
impenetrable look, hold me for just a lifetime long.

Should it end here I wouldn't mind too much. It's happened before
to art, love, America, God, and all the kids are traveling to India these days.
But would I encounter who it was that was?
I thought she might come back, pick up what goods I forgot, paid for
at the self-checkout station. There's nothing worse
than walking with no shadow. But the occasional high beam
isn't Canopus after all and the moon keeps breaking
up on me—oh, Dr. Neon, solve my migraine. Dr. Neon,
they keep your motion-sensor methods awake all night.
From the other side of sealed sliding doors
I see the lettuce heads beginning to limp. The waxed hams
suffocate through the plastic, Toucan Sam after Toucan Sam...
The rain is red and dripping. Dot matrices and myopia.
Under 44th street I heard your expenditures cling to the clock's last digits.
What sensitivities do I owe. I'm shaking off your debt.

III.

WESTERN WAY

In a place

 you left behind

 your mind

to walk away

 in the distance

 day-old snow.

An orange source

 floats in glass.

 Where did you

could you go?

 There is no middle

 to the sky,

no inland sea.

 The parish of the

 "co-inherence

of being in being"

 is only of divine

 and human regard.

Time will turn you

 outside-in

 like cabbage hearing

a so-and-so

 coldness arrives

 thus drawing to a point

like a loaded brush

 rubbery tips of leaves—

 Night

a sensitive aggression

 must be imagined,

 the wilderness

made for it

 inwardly.

The mind is a guest.
It roams the halls in identical mirrors
where walls merge, collapse and grow.

By now you know Giuliana. She is

 beautiful: her wide brow, and

eyes like the sphinx's,

 held down to their base with severity,

a possession really

 of their twin and deficient beauty.

There is something terrible

 about reality, and I don't know, she says

what it is.

 No one will tell me.

 But that *very fact*

that no one can tell

 or will

 is what is terrible

and to know this

 truthfully speaking

 I desire it

more than any man

 or woman I could

 for poetry give up

anything

for life (never before gone this way

 opens like

a field

 run through

 the heart: it roams

like the ray

 and from the pony's dance

 into a lifted leg

steps.

 Have you seen

 the white harbor, pulling in

the water and the sun?

 Look down:

 your legs are curling

into disappearance.

 The diver tucks

 drops and unfolds

exposes to us

 a second

 a window) is here and there

one picture now

 two from outside

 the mind:

sheets of snow

 fly.

WINTER VACATION AT PUNTA CANA

Into the sea
 all visible land slides
slips its lenience
 like the effortless magazine of life.
It is an empirical decline
 that would belie the enormity
of its effort, as each new wave
 hedges everything against itself, so
we do not grasp it,
 the brute reality which we must.
The scene of the crash
 must not be divorced from
what means of grasping we have:
 hands
 toes
 jaw
 clamp
 desk
 the bulk which
sometimes, by mere effect of
 the body's directionality and nerve, comes to know
the legion beats of
 nature's irregularity. It is not only
bonds of sea-song, then,
 that shift, do not break, with us, but also

the statistics of

 corporate retreat

 passive-aggression, "the notion" made

 up so stress-free we the majority have not thought to

 not want it— as for

our compulsion, stomachs

 shoved into placid shapes, squeezed aside into

intercostal aisles, spreading flat like

 Biwa stick beads into

universal aesthetic and the so-called

 adventurous escapade

with its simultaneous production of longing,

 instantly bridged without

making across what native-to-foreign screens

 would under certain

strenuous instances of the same sun be

 too hard to hide—

as for these, they always defend

what need they'd need/

 rioting past

 cerebral

 interference

 phone-

 propelling

 cabana

 fan-girl glare

and as I point out to you

white squiggles mounting the sea-smashed rock

I already wish for us

the irretrievability of our ever-remote insignificance.

FOR OLI BROWNE AND THE PROTESTS OF EARLY 2017

The difficulty of sustaining

 what one does

not achieve alone

 ever but always as

 renewal: This is

the present task,

 for it is the unconceived condition of

our mutual integration

 that would bring us

 into that,

and let us appear for once,

 at first,

 in the body

which we have not yet fully

 acknowledged.

For the body really

 does end,

 so wondrously

in the crowd that it

 snaps back

into what space

 contracts and grows overly magnetic.

We do not become

anything but ourselves,

the overwhelming

nature of this, finding in us

the free-radical flame.

From one end to the other

the chant flows like a river.

It is no elegy

and this is no poem.

The sanctity of your loss

betrays from you

what act would be the necessary destruction

to affirm and enter

into true joy of being.

You betray it now.

There is no power but the one there,

which you do not take as your own.

This is its gift, and as you know

the moon brims with its upkeep and is

tonight beautiful.

THE NEW AWE

In mud earth

 flexes the slow

ancient contra-

 diction of tense

deliberation:

 a state of change, bound

to an underlying shift

 the last human bones, rock and sheen

of purple:

 the agitation there

 can be felt, with adequate attention

 underneath

 and followed through to each

pulsation, the lush

 verdict paid through channels

so physical and various they

 eradicate from fragmentation

all trace of past fear,

 so each fragment

wanders

 all the while not losing the

connecting angle,

 surfaces out

the other end

 such dispersion of light like rainbow—

The spectrum infiltrates on pines

 shooting out of

mountainous pressure,

 that which sits upon a

sage-like gentleness,

 never short of ongoing

present

 tension:

how the droplet would almost then

 appear a solid

bounded completely by

 free surfaces

We do not escape

 our lyricism it seems, and urge

can be known only

 when the destructive contact is not

ultimately made

 or made into

false need hence

 preserved

 momentarily

impenetrable

WE'LL PROBABLY TALK BEFORE YOU GET THIS

The tree's outline's

 the world. The world's

outline's the size

 of two still

 eyes

inside

 a mammal head

 through branches

catching sight

A human cannot peer

 into his ear

given certain laws

 by which nature swears,

a pillow may cave

 causing

 to appear

Some dislocations

 like 32 teeth

mean to hang on.

 A membrane continues

with various openings.

 In every bird

two halves dwell.

•

The horizon is sometimes hard to see.
This is a question of lying inside a forest.
This is a question of American Electric Power.
This is a question
 of sometimes

the horizon is hard to name
 but easy to describe:
 "(Description) isn't
 definitive but
 transformative … particular … complicated … being…
intentional, improvisational
 purposive"; or

the horizon is sometimes
 easy to name *sherbert*
and difficult to describe

like the moment the doctor asks me to explain
 the pain in my back. The documents indicate
 minor deterioration in the L5 S1.

Sometimes it does this and sometimes that
and I feel this and that and I say this because I feel

•

Pain is always

 and it is always

partial, hence we forget

 a body

follows a sight

 and sight follows

a body, causing

 bodies. Visions

may or may not

 be visibly

same

 Since this will be through snail-mail I apologize your letter said, I read

 We'll probably talk before you get this your letter said, I read

Since I will forget the pain

Since it will be a matter of recalling

Since it will be a matter of convincing

(even from a

 woman to a woman

 doctor speaking)

Since I will not be able to stay with it to the end

 only to where and when I'm there

•

Brimming is a fact of life
 along with scintilla, twigs
and in-between
 letters, tranquilities
accessible by certain
 conditions (like after-
museum hours, or
 an everywhere *there*)
setting upon
 a body the way
the sun sets
 and resets

vision

 causing the storm
to disturb and drift
 where the sky doesn't
 open
and the ache doesn't
 either
but the membrane continues
 as I write *the membrane continues*
because it's this:
 What parts now, not

the last time you wrote

 of watches set by thunderstorms

as I read in a house

 and summer fell

through days—

 Not then, not in summer

but in Princeton

 and in

late summer,

 though you should know

for when you get back

 that sleep still on occasion

descends into

 the rest

 the waking hours

stumbling like flowers

 towards distant beds

and the pieces of the tower

 climb the tower well

as the mind moves farther along

 the mind not minding

its impatient fate

 never running

over "*till then*

 In Haste

Is it now?

 Are you there?

Will you follow?"

LIKE THE VOLUNTARY DISAPPEARANCE
OF SPACE BETWEEN ME AND YOU

Today beating the rain

hush-hushed

by the ordinary wall

the rancid rose

as I came down to play

by a very nature

concentric moods

and heard amidst it all

indecision

might as well wind up

by me the rose

keeping my hand

and by

maneuvering it

like a muddy crane

said.

The shadow-white cloud—

how many sides

 to it as it

deliberates

 over time

this is how a path

 begins to

and departs

 all along

 from

WE ASK NOT WHAT BUT WHO WE ARE

1.

What do you claim

 uncouth, desiring

 of the infinite beauty?

And of

 the pause

 a coolness in the passing?

A layer of sky

 like a tier of icing

 or a rapid growth and happening

marks the stretch

 required of not knowing

the precise manner

 of faltering

 should the mind falter

and marvel by mistake

Yesterday

 Something as simultaneous as it seems

 it can hardly be perceived

came to me

today demanding

A little of the consistent faintness

A proper finish *moves*
to the side

like a man who feels another

approaching from behind.

It withstands in that way

what motion is the sound which moves.

The sound which moves

is "the time the mvmt takes," is what
listens when I hear my voice

partition, earth

The distance of *something as simultaneous as it seems*

waits to pass *before turning*
to go through the man

it passes once more,

becoming by such means

what the enlightened moment seeks:

a way back to intuition

to be "found throughout

the known physical universe"

like an ordinary day in New

Jersey or Madrid.

•

A woman resolves to make an overwhelming thing:

madness

practice

control—

Like petals from their center

each intensifies equally

Last week for instance, when I flew the country to be with you
how could I have known the way my life would assert itself now?
All flight I watched the identical screens on the backs of heads,
the same tiny icon inching over state lines, pulling the red arrow
like a for-giftwrap ribbon. Meanwhile you expected me, kept track
of my delay over the currents of time, the large loopy sleeve of air
moving aside for a floating capsule of metal and light.

The force of immanence

first produces

then expires

the difference in which it

achieves and cedes,

to glimpse what "by

 virtue of the whole"

 is to luminosity a glimmer.

The mind needs yes time suspense travel

 but also love pull over on level 3 love,

 you're expecting me

the world is currently

 excessive I'm wearing those black leggings you

 detect behind the SUV the black Jetta oh I see you it's you

driving us the love

 your captain speaking, prompt, ready, manifest

like a name when

 I call you love and want to prolong it or when

I place an order expect it

 to arrive and it does days later the poem only

happens to end

 Truly I intend for it to extend infinitely, wait for us there

2.

Something as simultaneous as it seems,
 it can hardly be perceived
comes to stand in front from there within.
A little of the consistent faintness moves to the side
like a man who feels another approaching from behind
and withstands in that way what motion is the sound which moves.

Something as simultaneous as it seems
 waits to pass before turning to go through
the man it passed once more. It's as if the voice knew
that by hearing itself it could hear the partitioning of the earth
and by traversal of its source, learn to seal its distance again.

Something as simultaneous as it seems
 makes by such means
intuitive knowledge of the roads, and from the roads the coast
which leaps and hooks the sea into the mind
where it has never been known, if we know, to last.

•

Like a hand
something now presses
as if, as if

one day this day
 should glide through me
again
 unimpeded, the entire house
 a thought is as real as
the missing one
 In the morning light
all is *in medias res* —
 Its clarity as evidence
of what conditions
light and strip the scene
 to its severest part.
The storms instruct us:
 take hold displace yourself

The garbage cans later roll flat the sun

peel it
 and the crush of gravel
 lifts/ sweeps

 away rolls back
the sound what I return to
 what I mean to

 say

 is this wobble

this worming to neither side

of a brick window I see

resisting sight

can't be taught or

thought away.

 Indoors temptation sky

 glass androgyny

Isn't it enough being permitted

to stay at a time in each?

To know anything

of the day-to-day?

Something in your sound

is far-flung enough

to be wanted back

Time is no cheapskate

Nature is promiscuous

and come to think of it

waves are like

same difference

one captivates

another

releases

MINOR CANTATION

Akin to the significant "but,"
perceptible only
to thin shafts of mind

the rain fills in
in between space

The in between in between
space fills out

what's rest
left
celeste

IV.

NEAR, AT

This is one way of structure. To consume what's least desired first. A pepper's in the hummus. An eye's in the preference. Then crossing over, as it does, to choice. Your fingers pry open thick pages of Marx. Between teeth your pen-cap lodged. Preference betrays itself, is not enough. For a while the purple tip merely hovers, indicates continuous negotiation. Between horizons the sun decompresses. To discover the most various type of love, take a circle and stretch it till it bells flat like an oval. To practice the true length of difficulty, of coming back by way of the foreshortened, move along not one, but a nation of souls.

•

This is one way of structure. To impart auricular grace. Where you are music should be played. Instead, furniture inherently mismatches. But light retains in the flying insect screen. Thin wires approximate the planar situation as you recede, the situation catching the fearless tremble, inaudible music like a pre-cry. Then there breaks down. The brick turning soft. What is a point. "Why" is departure. Life's too important, you think, to be more-or-less. When you hear it, the motley of textures leaves goose-bumps blinking like a cable-box across your thigh.

•

This is one way of structure. Start backwards by counting past zero till you're collecting more than gifts. So the thought doesn't count and what does is something more real. The weather occasionally means itself, acquires in houses from the basement till rain is no longer XY from which even the poets can possibly grid, extract anything. An overtaking by content so that when we walk out, "it" has turned to hail and "it" is whacking us in every direction, hurting, saying what do you deny what can you possibly say does not belong, is intrinsic to your tomorrow, your life.

•

It's your life you think. But the cars slowly pass, and this too is one way of structure. A body in front divides and stitches doubt to a future impact. And what of your hesitation. Life, contrary to the extremes, road-blocked intermittently by certificated starts and ends, has fourth and fifth sounds. Has infinite and no versions. Do you think the wrens are frightened when you step into the yard? And when you feel "it's" slipping off you, being taken *from* you because you weren›t looking and went down the detour to defrost the cutlets, raise America, wake each night in a body whose arrival you're sick of but can't coerce your lover, your self, do you think then you are any less, any more alive? Resonation in air, my God, most sumptuous, defenseless, collective.

STEPS TO UNDERTAKE FOR WHOM IT CONCERNS

Head-first into the ground, hammered with wet nails that turn to glass in your ears. Rain cracks the geopolitical code from barrels shooting fraught skies. When the nation recedes faster than it arrives and morning is embezzlement into our dreams, who will be allowed to say. And who will lie. And who in this world will be left to mourn.

•

A stunning description you entwine around your finger and suck it dry. Safe by reduction you segue into the negative end of benches too cold for fucking. Red leaves and a group. A chain should be allowed to like and unlike, break occasionally from its freedom. When something hurts, it is to say I hereby acknowledge how we got caught up in our parts— vanishing in one another. There's something to be said about learning how to distinguish, then intersperse, the pain with the pressure.

●

What of the margin makes it sad. I'd like to forge from it an entire pie you are obligated to eat. By this point, every substitution of subjective position has stuttered. Call it stage fright. Call it a "manner akin to the living being." But "the living being had no need of eyes when there was nothing remaining outside of him to be seen; and there was no surrounding atmosphere to be breathed."

•

Contrary to the conflation of fear and desire, the pornographic love, like imagination, cannot crash. Fault is a shape of time as it fractures into a gray platform of disappointment's performance. Think of the smooth sensation. The softness. The weak light exterminating the glass with a wind-like caress. Slap-slap. Conglomerations of matters mutual-but-not-equal constitute the process of polysemous dazzling. I download the e-history of alienation. What you make is a loss of your life. But how to bash the affirmative statement. There is a relativity to what loneliness you can still call yours.

IS SPEAKING THIS CAN'T BE ALL

Every sad architecture contains a house-moon self. When I raise your hand I want to know who's asking. This is Step One I acquired in hindsight. You stare with your noise-cancelling eyes. A zipper of blackbirds sews the far end of the field. Can guilt be sold? There's too much to buy back. What of handing things over, what of

mute children and born-again innocence? Under the FDA sky-light America and Horace, every question from the beginning ever flown, flies: How, what time, does my love go

> where
> and what is near

•

Where and what is near God is one way of composing an answer against itself. The current shifts to maintain its yesteryear. The blind contour drawing lines up with what you see what can't be. As a kid did you mean what you are going to? Next to this it's

whom you want / how to
wake at all

But turn your back to the turnpike, tune into the Pacific's fantasia. There's summation of wind, contact, and surface. The sole rower oars his motorboat backwards, irons water through the mind's vault, lost times of your sentiment. The feeling, not unique, is indistinguishable from itself: what it is that's doing it, in which way, and what it was you ever thought would happen in the first place

·

It's my head obscuring what I want to see. In the puddle you-I-&-me disorders multiplicity, evaporates into

a thought: What do you think? The last first love crumbles like multi-gendered lusciousness gazed down a wall. For a year we exchanged secrets in a cubby. Back-sliding doodles. Some fear. The piling of notes, then more fear, to keep the love company

A miasma of dubiety, autumn starts to get you down. Thinking it's what you wanted, you're compelled to gauge personal accuracy. Step outside. A friend tooth-picks through the leaves. There's not enough time. Do you understand? I've got to get home. When the candle starts to tunnel, you let the wax stay. A canyon of softness so removable it's the idea of a nest. The impasse works up, then burns the rain. You can use my body you say. You can write this up, dance, or a cottage from the ground

PRIOR TIME

This is what they spoke. The ferns, the trees, the coat hanging like a pear from its stem. Light fastens to turning walls and this is what they spoke. A swing, a woman, a misbehaved dog. Children grow up like winter, which alone makes winter spring. There are those who win and those who already lose their love to novels or to the body. The bell rings. A woman dips her fingers into a manicurist's bowl. Who's there. The chromatic tones are later inside a man's mouth. Her legs put through his. The silence of news is heavy; the silence of morning is its benevolence. The imagined murmur of fishes tempers the color of silver against its caged reflection, so when rain anticipates discretion, children still speak into manual imitations of egg shells: the imminent conversation, as whenever the eye watches the path appear and reappear through the legs of passersby.

V.

UNTITLED (FOR AMERICA)

You said to the sea everything known, sell.

Things happen to me and don't when I sleep.

This is a way to be assorted. This is a way to be truly.

Sheared roses breed orange on mahogany.

We survive it. We covet a life after the party.

When it rains so we are talking up a staircase so we are

swimming in an aftermath and the waves come

crashing up on your dashboard like two bodies that know it—

Glass catches what we cannot end. Conserves from such

surface that which slants from us the speed:

Culmination of the extinct collided as universe breathing

•

They come so close. For a minute in the storm
leaves re-organize into lines.
A physical abstraction in slit air
aborts nothing, is instance of revolution within
what preexists. For a longer time
I have gone wet, dreaming of a neoliberal fate—the pattern of
stepping in, a fit perfected by anatomical discourse
and the initial design. Then,
as fate and I embrace and I am running my skin
through soft frontiers of hair,
practice grips, positions the reflector's edge.

Friend, from a certain disappearance, I can see
the tree is elm. Of what preempts, I speak
not of now, but as of it.

•

To enhance sensory congruence the dither
begins *in a soft voice.* Age fractioned
by getting the subject to drop its front shoulder:
a slimming technique, though also the posture of
a certain fatigue. Supine, you hear the whir
of helicopters land in your mouth, your dentist saying
spit. An unobstructed loop of sympathetic melodies
plays in elevators across America. "Making peace,"
Vestibular simplicity. Relegated to the seat most in-
visible to the rear-view mirror, you once read under
SYMPTOMS, "your eyes
are seeing the page," a steady going of the perfect
metrical distance, from which you
after the long ride
spit. An unobstructed loop of sympathetic
fatigue. Supine, you hear the whir of helicopters
begins in a soft voice, will first
have to kill you, say *I am*
leaving you, say, a slimming technique, the first
time will have to kill you

•

Ended up, we must cast our ballots
'gainst the vowel, eliminate effigies of "smooth-sailing,"
intercept a datum as

The pieces are granted access by way.
My pillow speaks to my blotted state in tongues, lets slip
there's no telling by folds
of sequence. But to say what one needs. To
exist to. The city's interior structure faints, and overwhelmed
by news of evidenced capacity, realtors find nothing
hard to believe. But you see it through, seek
your kind's progression like logic of thesauruses, a Greek sounding

At the center of these rumors you suspect
an echo of light is denser

•

Whole of trees intercepts the zephyr.
Details detail each other out of sight.
Hilltops retreat as aerial lattices re-
attach before me. A city's being built.
What you and I on the northwest corner of
Spruce and Linden see is but evidence
of us—a case of form above ground, like
collected dust in the particularization of
a superior but covert design

Concede we are getting somewhere.
Supple sheen where the boys lie,
all gone down on California, the first openly
female land with no kept promise.
A true protagonist is an open subject where
the wool may be distressed.
The males who are generous choose not
to disclose their names. Soon we may begin
to inseminate our enemies. Then they, who to
black eyes our naked voice everyday listen and
now say yes, love.

•

Hello. Still there?
Our voices are dancing, conceived.
Enganche. The static, oceanic, keels.
If rain reportedly does—then what else can't avail.
Not yet already gone, the choreography
of mayflies spans twenty-five hundred species.
Cared for by caring, the length of today
is the life of it. In chalk-like yellow the shirts
whimper and boast to retain their heat, their form
of understanding: my hand your chest:

Shapes like tadpoles in iron-cast ponds,
out from us "no longer" no more

•

Don't stop. The light alone has not

gleamed what emptiness, diamond-shaped and
steadfast on the library's green tufts, wants.
Even in the momentary steadiness (people reading with two hours left)
(rubber heels propped on outstretched oak) (the green carpet tense with
its oncoming)
difficulty persists. A room. An open locker's combination.
Confederacy of some billion mites. Constitution of

one street, doubled in a side's clear front.
A security guard with two baristas, an interior
brought and lost from the outside into
window glare, the way a flood not only has
but is direction. Think *sunset obscura?* and don't
stop you are thinking that diamond has

confided in you a nothingness, without which
you are most certain of your value and its.
Inexpression, not to be confused with
the unexpressed. But what remains below must
also know its way to skin, a bundle of you *per se*, so
whole and willing to trade two hours left
for how much there is to go

•

A superior but covert design, like collected dust
in the particularization of us. A form above ground
where a case of evidence is built of spruce and linden.
On the northwest corner of what you and I re-attach as,
lattices of sight retreat before a city's being.
Aerial hilltops detail each other's details out, while
the zephyr of whole trees intercepts

·

•

The internet thing is the never-ending scroll
plushness by a kind of vegetation, massaging what part of the head
is flattish, roundish. Under swift manual whisks
the mousey tease
promises dress-down of all pages
into one, complete, sensual, annihilation.
Thus, the secret of the secret: excitement over
anticipated failure to satisfy, tale of Sisyphus tied to the sound of
tsk tsk, like toy trucks, their re-called wheels
cat-fighting descent into nostalgic dirt

a pile of loose substance
which loads up like cream, pulls up
no real memory of what becomes of a given child.
·
As this further inaction displays
no true distance at all, we shrug off directionality, foggily
stick in our lap halfway between
dog and obedient theory, derivation of
tit-for-tat pleasure

Eternal god machine, physique of
the rushing hot mind,
am I just imagining things or do we share
an oversensitivity of drive.
Breathe once for yes. Twice, for no—

·

Begonias rest on Mao's face.

On this side, a gaze towards

heaven and free-world tears.

When one faculty overtakes the other

in instituted movements, bodies may be flown back as limbs.

But is the amputee yours? Afterwards,

a feeling that what's lost in the fingers must but

can't quite be matched with the sum of

certain pointing facts

·

You drive off a cliff. There is no cliff.
You do so backwards. Imagination is falling outside
the trees. From rag-like leaves inchworms sail
ever so gradually. What do you believe?
When there's felt and known gravity, the seen plummet
still does not deceive, defeat what holds us as steadiness to the ground.
We perceive the delay of noetic adjustment

Then we arise within the outpouring of a very word

•

It's what's been said. What's done. Everything is.
But language re-forms. Sometimes veers.
Come spring your neighbor's shrub sprouts forsythia.
The next, again. But only insofar
as imagining's borne in a remembering mind—that is,
you who re-call a cassette you've already checked out
wait upon meager ground, as winter has its own ways
of finding daphnes, or late camellias, both of which are
existing in their pre-existence. When we browse
your Netflix queue, we are simply happening, to choose

•

Form a ground above case evidence. A covert retreat, collected like dust in the particularization of being. Built of superior spruce and linden, on the corner of what you and I reattach as, lattices of sight design northwest of us a city, while aerial hilltops detail other details out. Before the whole of zephyr-trees intercepts me, see each.

MY CHRISTOPHER POEMS

LESSON BY WAY OF BENVENISTE

Everything outgrows
we who outgrow

who else but you

loves what you loved

and loves you in turn, as if you were that, and simple

nature changed
is nature, and change of
address, weather
hands

becomes the you you are
says to you what's loved
changes, as to remain

changing who loves

10025

The city is the loneliest place
burning

and unable to sleep

A beautiful clock with an equally gorgeous laugh
 it draws from the shy bowels of yarn
 whatever can't go back

Then tell some story
Like the one where you're from

who you are being
or thinking of at least

Today
unable to sleep for the third night in a row
it's you

which reminds me

how little difference there is
between the city and the love for it

Someone will say it's Wednesday
But only technically
The sun has yet to rise

As for you
tossing in the dark
in my mind

you, stay,
keep me here
tell me how it went

our life for the billionth time

CATSKILL, NY

Were you here
I wouldn't have to convey
a certain appearance

how from a high-up clearing, a belt of distant mountains
sits inside a closer range,
how the river fastens
first on the left before coming down
on the passenger side

taking thirty minutes all-in-all
but also how
up here, it is very blue
and very cold. Bluer and colder
than what I know you
are used to feeling

which I ask you to tell me
not because then
I'd know
or for the sake of
romantic progression

but because
the redundancy of human life
is figuring it out

is what to get her every next
year on the twenty-fourth of June
is the first
second morning of a haircut when
"something's
different" happens to be noticed
and you know it and get to say.

SHOULD I RUN

out of things to say, be slow
and give me
the things to see:

a town
food in your hair
some episode under
your roommate's Hulu account, or something, say

handsome and abstract:
Twombly
a sign
the past

 two summers I spent

 first getting to know you

 then myself

with you
but also when

I am missing you because
"a woman is alone"
vs. when you have merely taken to

deeper and longer sleep

which I, being beside you
will want to know if it's
the case
 or whether I am wrong and it's

really more shallow
more wide, like an exhale at the pool.

Funny then, how a whole night with you
for me has passed
with you arriving when you will

so all the canyons of America, the best of my twenties
will be there I can't
say for sure though

taking your chance this
morning just by
sleeping it in
you seem already
to have told me so.

QUIET FLIRTATION

Let me see you again,
though I haven't
told you I think it

with all my better
thoughts I
leave in me

It's not
that they're mine, but that they, in
being, have a certain hold
over the universe, like money, or law—

Any future is like that.
A certainty, yet
built into the very defenselessness of its coming.
Believe, if not me, then
what I cannot control,
unreal and real my thoughts are

spoken to be spoken back to,
but not to be made
entirely unfathomable
by you—

only when
I should no longer
have me in them
shall it seem
getting any more
of me to you
without being me
to you
might be again
impossible, and true.

HEAD CLEARANCE

Soon there's only you
and the idea of you.

Basic steps
like whether you should text first
or believe in the dark
meaning of clouds.

But say you should.
Action remains
another matter, lodged between
the way things precipitate
and pass. The ocean, unable to stop,

results in presupposition:
eternal cause, with no
definitive motive—as compulsive and real
as what happens when your maybe-
love does not respond

which is everything and nothing at once.
Then,

is love love, intimacy so
strange as when you run off
with your neighbor's
one neighbor. Or why we do

anything, trying so hard
with who we could have been
when the answer resembles nothing.

THE PARDONING

Like the whole of the universe
you are nowhere in sight

How am I to be then?
How am I to mean
the things I intend

for you, for me
at every hour
if wind is sleeping? carrying over
in its suitcase, old lover, truth

So it does not? Forgive
me. A sight
you are nowhere in
cannot be mine

Additionally, how simple
everything does
does not seem

DEVICES

When I ripped out
my heart my body

kept walking

It walked through
summer through the
summer rain

abominable carts
sitting in lots
upholstery

slicked hot to
car-belts and quads
and besides these

the idea of sun

which was not in those days to come to
the sun
excelling high and
far above anything I was

to understand nothing
though now that that is then

what remains, not the
lesser portion but only sense

and a sense of the sense

THE MESSENGER

What do I want
to you to say
now no not that

tainted
evaporated

 touch

me harder
words weighted
belonged in
something farther

love's the attempt
at one another

love's the age
for love's age
the requisite

 light as night
leaving

Cupid's last offer

as if I should come
as if I should not

go

Now that I am alone
it is some knowledge

though not of much use

To speak
to go
to illuminate the street with a phone
dying in my hand

though it is not even night
and even if it were

wouldn't that be something

like a woman who keeps what she wants away
but also leaves her eye on it so that
she can in fact see it and not

crush the distance
you and I have

I cannot I suppose know

how there is no use in this knowing
or how less than obvious we ought to get

The party which thickens
distills into sudden plainness
and we are as we were

getting somewhere

back there, if we passed it
right here, if it's what we had in mind

NOTES // ACKNOWLEDGMENTS

"Giuliana" in "Western Way" refers to the main character in the 1964 film *Red Desert*.

The quote beginning "Description..." in "We'll Probably Talk Before This" is a deconstructed quote from Lyn Hejinian's *The Language of Inquiry*.

The quote in "Steps to Undertake..." belongs to Plato's *Timaeus*.

In "We Ask Not What But Who We Are," "the time the mvmt takes" is from James Joyce's *Ulysses*.

My Christopher Poems is an ongoing series of poems begun in 2018 that extends into the foreseeable future.

To the following, I owe my deepest gratitude: Carly Dashiell, Dan Machlin, and Ariel Yelen at Futurepoem, for their utmost support and talent in seeing this book through, as well as Pierre Joris, Monica McClure, and Claudia La Rocco for their early support of the manuscript. Selections of this collection have appeared in *Berfrois, DIAGRAM, Fanzine, Flag & Void, glitterMOB, inter/rupture, Prelude, Queen Mob's Teahouse,* and *Social Text,* and I am grateful for the editorial support of these publications. Finally, to my given and chosen families, thank you.